HAUGHMOND
LILLESHALL A

MORETON CORBET CASTLE

SHROPSHIRE

Iain Ferris

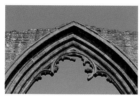

Haughmond Abbey and Lilleshall Abbey are two of the best-surviving medieval monastic sites in Shropshire. Both abbeys were homes to communities of Augustinian canons and, until their suppression in the 1530s during the reign of Henry VIII, played an active and important role in the economic and political life of the region.

By chance, at Haughmond time has favoured the better preservation of buildings around the cloisters, while, in contrast, at Lilleshall the church has survived best. Viewed together, therefore, the two sites give us an understanding of how the abbeys functioned and the religious and domestic activities carried out there.

A Civil War siege destroyed part of Lilleshall Abbey, while nearby Moreton Corbet Castle was also left in a ruinous state after its capture by Parliamentary forces in 1645. Nevertheless, the castle still represents a fascinating example of a medieval Marcher private stronghold, with the remains of part of an Elizabethan house testifying to the ambition and taste of Robert Corbet whose family had owned the castle since 1239.

❖ CONTENTS ❖

Published by English Heritage
23 Savile Row, London W1S 2ET
www.english-heritage.org.uk
© English Heritage 2000
First published by English Heritage 2000, reprinted in 2005
Photographs, unless otherwise stated, were taken by English Heritage Photographic Unit and remain the copyright of English Heritage

Edited by Lorimer Poultney
Designed by Derek Lee
Artwork by Hardlines (p.17), Peter Bull (p.5 and inside back cover)
Printed in England by The Colourhouse Ltd, London
ISBN: 1 85074 750 4
C10, 05/05, 08062

HAUGHMOND ABBEY
TOUR AND DESCRIPTION

❖

Haughmond Abbey, also known as the Abbey of St John the Evangelist, as seen today comprises the remains of much of the later phase of the medieval monastic complex, arranged around two cloisters and terraced into a hillside to the east. The unusual plan reflects the

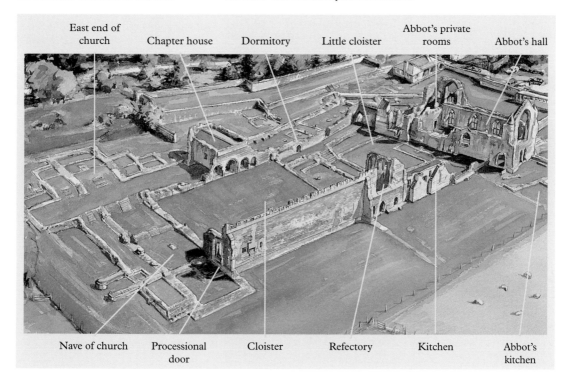

East end of church Chapter house Dormitory Little cloister Abbot's private rooms Abbot's hall

Nave of church Processional door Cloister Refectory Kitchen Abbot's kitchen

The impressive gable end of the abbot's hall, with the twin doors to the abbot's kitchen

sloping nature of the site. The better preserved remains are those ranged around the southern, or little cloister, and the chapter house that stands on the eastern side of the main cloister.

The original entrance was on the northern side of the site, on the other side to the present entrance, and was probably guarded by a gatehouse. The present entrance dates from the sixteenth century, after the abbey had become a private residence. In the woods above the abbey a well-house was built in the fourteenth century.

Start at the south end of the site, close to the present site entrance.

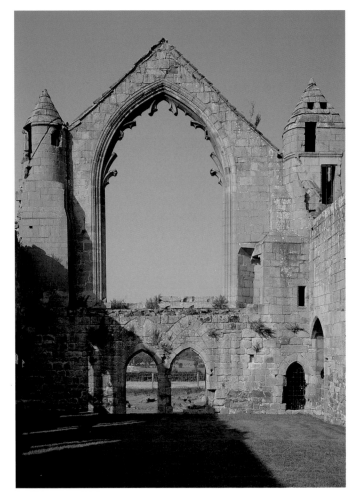

THE ABBOT'S HALL AND HOUSE

The tour begins outside the highly decorated south bay window (**1** on the site plan) of the **abbot's private rooms**. This window is actually later than the building itself, and was probably inserted in the late fifteenth century to replace the original window. A doorway to the left of this window leads into the fourteenth-century **abbot's hall** (**2**). Off the hall to the right are the earlier thirteenth-century **abbot's private rooms** (**3**) and to the left is the **abbot's kitchen** (**4**).

The abbot's suite of rooms would have been decorated and furnished in an expensive manner appropriate to the importance and status of the head of a monastery such as Haughmond. This can still be seen in the rich deco-ration of shields, grapes, rosettes and roundels on the inside of the bay window in the private rooms, for instance, and the raised podium in the abbot's hall on which would have stood the abbot's high table.

The large fireplace in the hall was added in the sixteenth century when

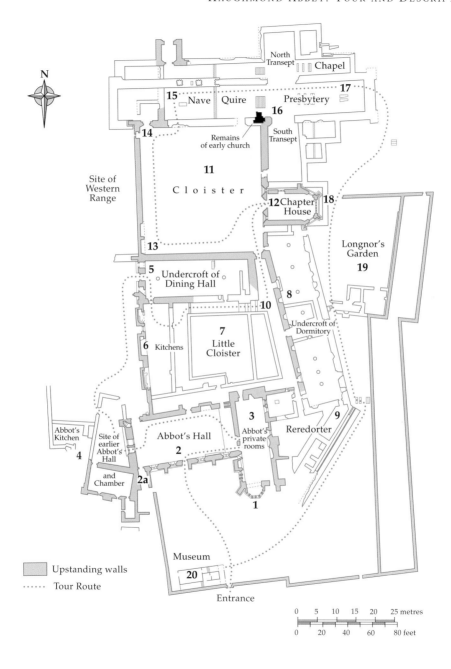

N

North
Transept

Chapel

15 Nave Quire

Presbytery 17

16

South
Transept

Remains
of early church

14

11

C l o i s t e r

Site of
Western
Range

12 Chapter
House 18

13

5 Undercroft of
Dining Hall

10 8

Undercroft of
Dormitory

Longnor's
Garden

19

7
Little
Cloister

6 Kitchens

3

Abbot's
private
rooms

9

Reredorter

Abbot's
Kitchen

Site of
earlier
Abbot's
Hall

Abbot's Hall

2

4

and
Chamber

2a

1

Museum

20

Entrance

Upstanding walls

Tour Route

0 5 10 15 20 25 metres

0 20 40 60 80 feet

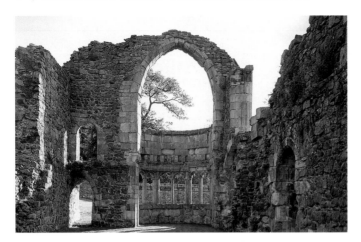

Inside the abbot's private rooms, looking towards the later bay window

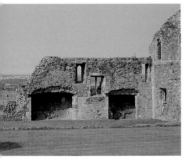

ABOVE: Looking across the little cloister to the fireplaces in the canons' kitchen

RIGHT: Entrance to the undercroft of the canons' dining hall, with the large window above that lit the refectory on the first floor

the building formed part of a private house created after the dissolution of the abbey. The original hall was probably heated by free-standing braziers.

The private rooms survive today as a two-storey building, originally subdivided into individual rooms by screens or partitions and much altered over the years. It possibly had its own private latrine or 'garderobe' reached through the door to the left of the bay window.

Before leaving the hall, in a narrow passage on the left is a L-shaped pavement of miscellaneous glazed medieval floor tiles (**2A**) found around the site and reset here in concrete. While obviously a modern creation, this pavement nevertheless gives an impression of the type of decorated floors that would have existed inside the church and other abbey buildings.

The kitchen, connected to the hall by the double doorway through which servants would have brought food into the hall and through which you should now walk, was built over the site of an earlier hall and chamber, little of which now survives.

DOMESTIC BUILDINGS

Leaving the abbot's kitchen and proceeding towards building **5** on the site plan, on the right you will notice the backs of three large fireplaces set into the rear wall of another kitchen building that lay on the west side of the little cloister.

You now enter the ground floor, or undercroft, of the **canons' refectory** (**5**) where food and drink would have been stored. The refectory, or dining hall, would have been on the upper floor, reached by a stone or timber service stair from the undercroft below

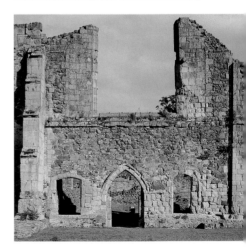

and by the canons from the higher level of the main cloister where you will later see the decorated entrance door. As might be expected, the refectory undercroft connected with the **canons' kitchens** (**6**) which lay on the west side of the **little cloister** (**7**). As you walk through the connecting doorway into the kitchens you will see on your right the remains of the three large fourteenth-century fireplaces whose backs you saw earlier, and where the spit-roasting of meats and the cooking of food in pots and cauldrons would have taken place.

On the opposite side of the little cloister are the very slight remains of the lower floor or undercroft of the **canons' dormitory** (**8**). As in the refectory building, the undercroft would probably have been used for storage, while the dormitory proper would have been on the upper floor. At the south end of the building there

would have been access into a communal washing and latrine block, known as a **reredorter** (**9**), of which only a length of stone-lined drain and some fragmentary walling is visible today. In the mid-fifteenth century the north end of the dormitory was divided up to create private quarters for the abbot's deputy, the prior, with access to a newly created garden on the east side of the building.

MAIN CLOISTER AND CHAPTER HOUSE

Returning to the little cloister, a set of steps leads from the little cloister into the **main cloister** (**11**). Turning left, at the south-west corner of the cloister you can see the doorway (**13**), with Romanesque style decoration, that led into the dining floor of the canons' refectory. Two recesses in the wall here mark the former position of a laver or

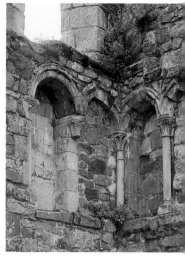

Detail of decoration in the canons' dining hall

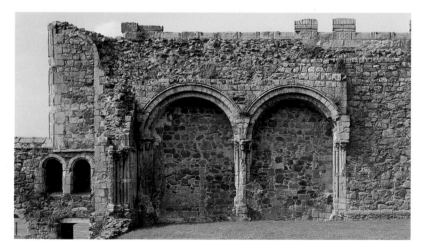

The two arched recesses in the cloister for the laver or basin

basin outside the building where the canons would have washed their hands before proceeding to meals inside. Crossing to the east side of the cloister, you will find the **chapter house** (**12**), with its three richly decorated late twelfth-century arches, the central one of which forms the doorway into the building from the cloister. The figures of eight saints standing

❖ THE CHAPTER HOUSE SAINTS ❖

The identity of each of the saints carved on the chapter house arches at Haughmond is revealed by their accompanying attributes. Looking from left to right they are: St Augustine, after whom the Augustinian Order was named; the martyred St Thomas Becket; St Catherine of Alexandria, depicted with the spiked wheel on which she was martyred, and in the act of extracting revenge on the Roman emperor Maxentius

who had her killed; St John the Evangelist with his emblem, the eagle; St John the Baptist with a lamb and flag; St Margaret of Antioch slaying a dragon; the locally venerated St Winifred with her murderer Prince Caradog; and the winged St Michael slaying a dragon.

The presence here of St John the Evangelist is not surprising, given that the abbey bore his name, and that his image also appeared on the great seal of the abbey.

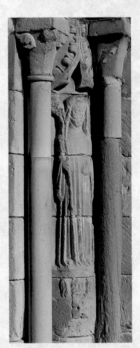

Detail of the figure of St Winifred, whose shrine was at the Benedictine abbey of Shrewsbury, only a few miles away. Shrewsbury Abbey had acquired the saint's relics in 1138, not long after the foundation of Haughmond itself

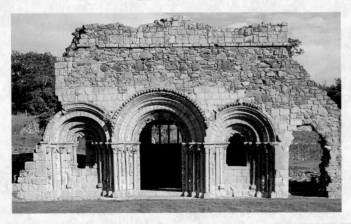

The three-arched front of the chapter house

under architectural canopies were carved between the arch shafts in the fourteenth century.

The canons met in the chapter house daily to discuss religious business with the abbot and to deal with non-religious matters relating to the running of the abbey. Nevertheless, these business meetings were introduced by the reading of a chapter from the rules of the order, hence the name given to such buildings at monastic sites.

No trace remains today of the benches or seating that would have been arranged around the walls of the room. Indeed, the building was drastically remodelled around 1500, towards the end of the life of the abbey as a religious establishment, and they may have been removed at this time. The present timber ceiling also probably belongs to that period. A number of tombstones are displayed inside the chapter house, possibly removed from inside the church, and part of an octagonal font that probably also came from the church.

Leaving the chapter house and crossing the cloister to its north-west corner you will see the **processional door** (**14**) that led from the cloister into the church. It is highly decorated on the cloister side, and in the fourteenth century two almost lifesize sculptures of St Peter (on the left) and St Paul (on the right) were carved on the shafts on either side

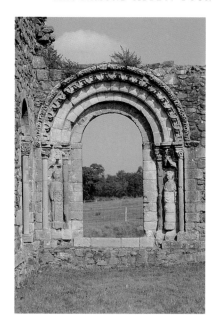

Processional doorway from the cloister to the church

of the doorway. You should enter the church by walking across the low wall to the right of the processional door.

CHURCH

Little of the **church** (**15**) survives, although its plan can be made out on the ground. A few isolated foundations of the first, small early twelfth-century church can be seen (**16**), but the majority of the walls here belong to the larger mid-twelfth-century church that replaced it. A north aisle and north porch were built on to the nave in the thirteenth century, and in the fifteenth century a narrow chapel was created to the north of the presbytery.

Looking across to the cloister, with the foundation walls of the church in the foreground

The church is 60 metres (200 feet) in length, in a standard cruciform (or cross-like) shape. The east end is terraced into the hillside, so that the altar would have been some 4 metres (12 feet) higher than the floor of the nave. Progress from the nave into the choir and towards the high altar would have been by a number of steps. At the east end of the church are the grave-stones of John FitzAlan and Isabel de Mortimer, patrons of the abbey in the thirteenth century, buried here in a prime position in recognition of their generosity (**17**).

Leaving the church at its east end, make your way back towards the site museum. On the way you will pass on your right the east end of the chapter house where earlier, twelfth-century wall foundations can be seen (**18**). On your left, a little further on, is an open, grassed area that was a garden in the later medieval period. Known in the mid-fifteenth century as Longnor's Garden (**19**), it was created for Abbot Nicholas de Longnor, and is known to have contained a dovecote – pigeons providing not only meat for the dining table but also dung for use as fertiliser. The garden was presumably also used for growing culinary and medicinal herbs, known to have been common plants in monastic gardens.

Returning finally to the site museum (**20**), you can view a small exhibition on the abbey which incudes a display of sculpture and other finds from the site.

HISTORY

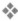

THE FOUNDING OF HAUGHMOND

A small religious community – 'Prior Fulk and his brethren' – was first established at Haughmond some time towards the end of the eleventh century, around half a century before the formal founding of an Augustinian abbey on the site in 1135. The patrons of the new foundation were the powerful FitzAlan family, Lords of Oswestry and Clun, whose growing regional influence over the next few centuries, and royal connections in the mid-twelfth century, guaranteed the abbey generous gifts and endowments and a securer financial status than many other monastic houses of the time. This prosperity was reflected both in the extent of the abbey complex and in the style and decoration of its buildings.

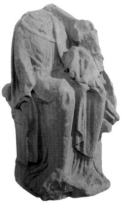

Stone carving of the Virgin and Child found during excavations. It may have originally formed part of the decoration of the early thirteenth-century cloister

❖ THE AUGUSTINIANS ❖

The Augustinian Order of canons and canonesses – 'the black canons' – based their 'rule', or the way that they organised their lives, on the writings of St Augustine of Hippo, after whom the order was named. Canons were ordained priests, which distinguished them from monks, only some of whom were priests. Canons therefore did not necessarily lead secluded lives, but often worked or travelled outside their monasteries and attended to the needs of local lay communities. Augustinian monastic houses were usually quite small and modestly appointed, so it is unusual that both Haughmond and Lilleshall attained the status of an abbey, most houses having the lesser status of priories. Over 200 Augustinian houses were established in Britain, with particular concentrations in the Midlands and East Anglia.

WEALTH AND DECLINE

Like many monastic communities, Haughmond Abbey owned a considerable amount of land, most of it locally, and derived income both from rents, and the farming of parts of its estates through 'granges' (farms). A good impression of the financial dealings of the abbey can be gained from reading the abbey's 'cartulary', or records book, which appears to have been compiled in the last quarter of the fifteenth century. As well as the agricultural details, accounts of the income derived from the operation of some 26 mills in Shropshire at the end of the thirteenth century show what an important source of revenue this was. Some of these mills were fulling mills, used for the processing of woollen cloth, suggesting that the abbey shared in the considerable prosperity of the local Shrewsbury cloth trade in the later medieval period.

❖ THE MONASTIC DIET ❖

The monastic diet of the canons at Haughmond was perhaps more varied and rather less severe in its routine rigour than that enjoyed by many other monastic communities elsewhere, although this may not always have been the case. Daily meals of vegetables and bread washed down by water or ale, with dishes of fish or meat only on the table at feast days and festivals, can be assumed to have been the routine in the early days of the abbey's existence. However, in addition to locally grown cereals, vegetables and garden produce, later records show that supplies often came from further afield and were more varied. The abbey cartulary records the dispatch in 1280–81 of 147 sheep and one calf to the abbey, the latter especially for the visit of the bishop. The record of the imposition of a small tithe in 1336 which required one individual to supply the abbey with a hen each Christmas probably represents part of a larger supply network for obtaining both chicken meat and laying birds.

Tithes of sea-caught fish are recorded in the cartulary as having been exacted from the community of Nevin in Gwynedd at the end of the twelfth century, while in the mid-twelfth century Earl Ranulf of Chester granted the abbey use of a boat on the River Dee and rights to purchase on special terms up to 6,000 herrings per year at Chester. These would be in addition to any fish supplied to the abbey from its local fisheries and fishponds, and eels from some of the mill pools.

Even this was obviously not enough, for an ordinance of 1332 specifically calls for an upgrading of the abbey's cooking and dining facilities, and for an improvement in the 'simple' food eaten in the refectory. A new kitchen was to be built quickly, with reliable local sources of meat and fish, and for 'fuel, flour, peas and all kinds of pottage, bronze cooking vessels, cheese and butter' to be

Other documents, on the other hand, show that towards the end of its existence the abbey was beset by both financial and moral problems. Financial irregularities arose from the use of the income from one of the abbey's grange farms, and as a consequence Abbot Richard Pontesbury was disciplined for allowing the infirmary, dormitory, chapter house and library to fall into disrepair through lack of funds towards their upkeep. Falling moral standards and a lack of discipline were reflected in the reports of official visitations to the abbey, which noted that novices were not receiving proper instruction, that canons visited nearby Shrewsbury too often, that a 'woman of ill-repute' was twice named as frequenting the abbey, and that boys had been found in the dormitories. More serious still was the disciplining of Abbot Christopher Hunt in 1522 for fornication and a generally poor administrative record.

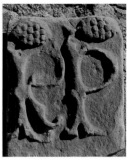

Stone carved with the initials 'R P', possibly for Abbot Richard Pontesbury (reigned 1488–1521).

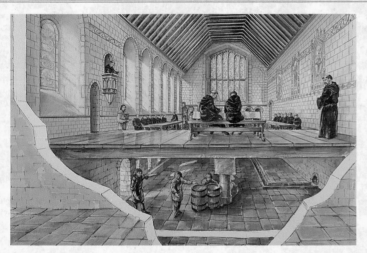

Reconstruction drawing of the monastic refectory at Haughmond. Benches would have been arranged along the walls and there was a pulpit where readings from scripture would be given during meals

purchased out of abbey funds. Furthermore, pigs were to be reared in a pigsty outside the abbey gate and 20 supplied each year to the kitchen, together with two consignments of wheat per year for making pastry.

Reference to a cellarer reveals that ale was drunk, and possibly brewed on the premises, as may have been mead from honey, if the canons were able to take advantage of situations such as the one that arose in the mid-twelfth century when they were granted half of a swarm of bees in woods at Hardwick. It is also likely that pigeons from the dovecote in Longnor's Garden ended up on the abbot's table in the fifteenth century.

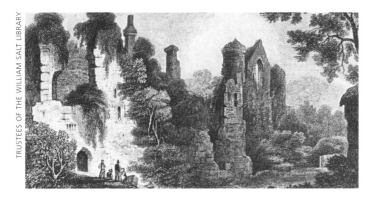

Engraving of Haughmond Abbey by Francis Calvert, 1830, showing the outside of the refectory and the gable end of the abbot's hall

While not necessarily renowned as a seat of learning, it is nevertheless worthy of note that reference is made in 1518 during a visitation of the abbey to the poor state of repair of the library, and that in the earlier fifteenth century the abbey was home to John Audelay, the deaf and blind poet, whose two books of devotional poems were written at Haughmond where he served as a clerk and chaplain.

In 1403, the battle of Shrewsbury between King Henry IV and rebels led by Henry 'Hotspur' Percy, during which Percy was defeated and killed, was held on the slope of the hills about two miles to the north-west of the abbey. The battlefield site can be visited today.

THE DISSOLUTION OF THE MONASTERY

The abbey was dissolved in 1539 during Henry VIII's nationwide Dissolution of the Monasteries. Records show that the abbot and ten canons were present at the abbey to sign the deed of surrender. All of them received quite generous pensions. The abbey's annual income was estimated at just under £250, a relatively substantial sum that testifies to the financial acumen of earlier abbots whose investments had helped the house prosper through later, leaner times. Shortly after the dissolution the abbot's hall and adjoining rooms were converted into a private residence by the new owner of the site, Sir Edward Littleton. At this time the demolition of the church and dormitory had probably already begun, and the robbing and reuse of stone from these buildings probably continued under the subsequent owners, Sir Rowland Hill and the Barker family.

LATER HISTORY

Some of the other buildings around the little cloister also continued in use as residential accommodation up until the Civil War, with the little cloister itself becoming a formal garden. A fire during the Civil War marked the end of the site's use as a higher status residence, and it was then turned over for use as a farm, in which role it continued up until the earlier part of the twentieth century. A small cottage was still standing in the area of the former abbot's kitchens when the ruins were placed in the guardianship of the Office of Works in 1933. The site is now in the care of English Heritage.

LILLESHALL ABBEY
TOUR AND DESCRIPTION

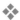

Lilleshall Abbey, as seen today, comprises the remains of the central parts of the original twelfth- and thirteenth-century medieval monastic complex, principally the church and other domestic buildings around the cloister. Further ranges of buildings, including the canons' dormitory, stood to the south of the guardianship site, and a lady chapel is known to have existed to the north-east of the church.

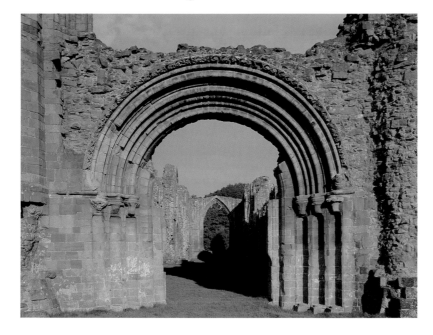

The great west door of the abbey church

The monastic complex was enclosed by a precinct wall, only parts of which remain today on the south, east and north sides, while a gatehouse would have stood by the main, north entrance close to where you turned off the main road to approach the site. Between the gatehouse and the church was an outer courtyard, around which would have been ranged various agricultural and industrial buildings, including, it is thought, a barn or stable, and perhaps a water mill. Nothing of these buildings is visible today. In front of the church there were two stone crosses.

The tour begins at the west front of the church (1 on the site plan), a short distance away from the present site entrance.

THE CHURCH

The church is the largest individual building at the abbey, and in plan follows the traditional cruciform or cross-shape layout.

The west front (**1**) of the church, which would have caught the eye of visitors to the abbey as they crossed the outer court, retains traces of a tower, supported by the two buttresses either side of the arched doorway. You enter the church through its great west door which may have originally been flanked by free-standing pillars or statues of saints placed in the now-empty niches on either side. Traces of the seating for an enormous wooden door can be seen on the underside of the arch,

East end of the church, showing the fourteenth-century window inserted in the late twelfth-century presbytery

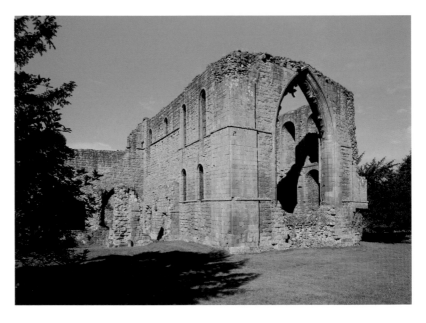

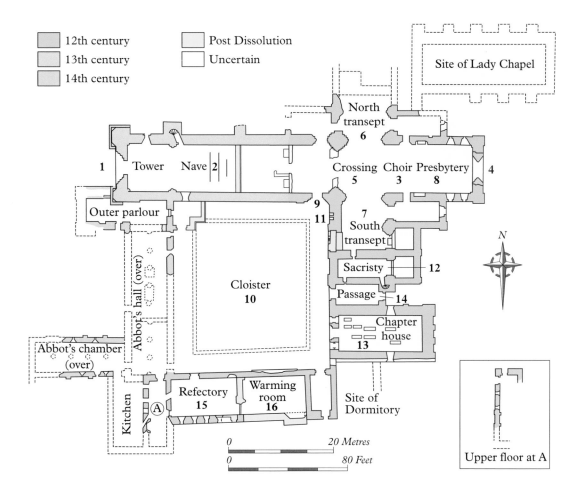

12th century
13th century
14th century

Post Dissolution
Uncertain

Site of Lady Chapel

North transept **6**

1 Tower Nave **2**

Crossing Choir Presbytery
5 **3** **8** **4**

9

11

7

South transept

Outer parlour

Abbot's hall (over)

Cloister
10

Sacristy **12**

Passage **14**

Chapter house
13

Abbot's chamber (over)

Kitchen

(A)

Refectory **15**

Warming room **16**

Site of Dormitory

Site of Dormitory

0 20 Metres
0 80 Feet

N

Upper floor at A

and for its hinging at the sides of the entrance way.

Passing through the door, you have a clear view along the **nave** (**2**) and **choir** (**3**) towards the great **east window** (**4**). From this point the

unusual length of the church can be best appreciated – nave and choir having a combined length of over 60 metres (200 feet). In the medieval period such a clear view would not have been possible as the church

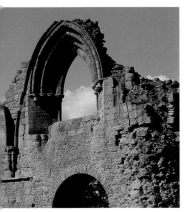

North wall of the nave, with one of the springers for the vaulted stone ceiling

would have been divided laterally by three screens, the positions of which are marked on the ground today by their stone foundations.

It is important to understand the significance of the subdivisions within the church created by these screens, as they reflect the different functions of each area and tell us something about the social relationships between the various occupants of the abbey. The western end of the nave, the end closest to the great west door, would have been used for services by the lay brothers (those who undertook the manual labour around the abbey and in its gardens and who followed a very different daily routine to the canons) and by any secular visitors to the abbey. The eastern part of the nave up to the crossing would have been in daily use by the canons, while the choir, as the name suggests, was largely the preserve of the choir canons who sang the services. Beyond the choir was the **presbytery** – the site of the main, or high, altar. No trace of this now survives.

As you walk along the nave, the remains of a number of stone vault springers on both the right- and left-hand walls show that the nave had a vaulted stone ceiling. On the left-hand side are the remains of a spiral staircase that led to a second-floor gallery which probably extended the whole length of the nave up as far as the crossing.

Crossing and transepts

Over the **crossing** (**5**) itself there might have been expected to have been a tower, but the absence of a staircase and the unequal dimensions of the crossing piers suggest that no tower existed. The piers did though form the bases of four arches, at the east end of the nave, at the west end of the choir, and leading into both the north and south **transepts** (respectively **6** and **7**). Leading off both the north and south transepts are small, plain side chapels, one of which must be the Chapel of St Anne named in the Dissolution inventory. A doorway from the south transept also led into the sacristy.

Choir and east end

If you go now into the choir, you will notice on both your right and left two recesses cut into the lower parts of the choir walls. These originally housed decorated tombs but are now empty. At one time the recess on the left is recorded as having contained the effigy of an abbot, and that on the right a statue of a knight, presumably one of the benefactors of the abbey buried here in recognition of his services to the monastery. It is thought that a set of plain wooden choir stalls now in Wolverhampton Church originally came from the abbey at Lilleshall and may have been stripped out of the abbey church at the time of the Dissolution. The east

end of the church, lit by the great east window formed the presbytery (**8**).

THE CLOISTER

To leave the church, retrace your steps to the west end of the nave, and go through the east **processional door** (**9**) that linked the church and the **cloister** (**10**). Plain on the church side, the door is ornately decorated on the cloister side with chevron decoration in the Romanesque style. On your left as you come through the door from the church is a **book locker** (**11**), again with chevron decoration above. The locker is divided into two compartments, each of which is rebated for a wooden door, while the central stone projection that forms the division between the two compartments is shaped to hold a bolt for locking the doors.

The positioning of the book locker here suggests that at Lilleshall, as at most other monastic houses, the cloister was not just a thoroughfare into and out of the church, but also at times a place for quiet contemplation, reading and study. Though there is no evidence here for any of the cloister walks being laid out with dedicated private study areas or 'carrels' – this is known to have occurred at other monastic sites. It is known that John Mirk, a canon at the abbey in the early fifteenth century, wrote a number of religious works, one of which was

Processional doorway from the cloister into the church, lavishly decorated with 'chevron' patterns in the Romanesque style and dating from the twelfth century

printed by William Caxton in 1483 in *The Golden Legend*, and it is tempting to think that he may have composed these books here in the cloister in which you now stand.

The inventory taken at the time of the Dissolution refers to the cloister roof, which was probably of timber-framed construction, to roofing shingles, which probably would have been of oak, and to paving-stones for flooring the claustral walks. This helps give us a better idea of the original appearance of the cloister.

The cloister itself is small, *c.*30 metres (*c.*100 feet) square, and is now open on its west side, where only a few stubs of low walling survive from the range of buildings that provided private accommodation for the abbot and a hall where his public business could be conducted. The abbot's

Book locker

private rooms, hall and chambers were converted into a dwelling house following the dissolution of the abbey, but were probably destroyed after the Civil War siege of the site.

Chapter house

The eastern side of the cloister housed the **sacristy** (**12**) and **chapter house** (**13**). The sacristy can also be reached directly from the south transept of the church, but you will enter it from the cloister. In the sacristy, under the care of a sacristan, would have been stored church vestments, sacred vessels for the services and perhaps the choir books. In the southern wall you can see the remains of a spiral staircase, which led to an upstairs room that may have been used as a treasury, for the secure storage of the church plate and other valuable items.

The sacristy is separated from the chapter house by a vaulted passage known as a **slype** (**14**), which provided access from the cloister into what is today an open, grassed-over area but which in the medieval period was probably the site of the canons' cemetery and possibly also of an infirmary building. Inside the chapter house can be seen a number of grave-stones recording the burial here of some of the abbots of Lilleshall.

Refectory

The tour ends at the **refectory** (**15**), which formed the range on the south side of the cloister. This originally consisted of a single, large, well-lit room in which the canons ate their meals, with the abbot seated at the end of the hall furthest from the door.

The refectory is entered through a large arched doorway at the west end of the building and is lit by a series of Romanesque-style windows which replaced earlier, probably less elaborate openings. Opposite the door is a recess for a small laver or basin, decorated with chevrons, which was probably used for the washing of hands before each meal.

The slight remains of the founda-tions of a pulpit can be seen in the south wall of the room. During each meal readings from the scriptures would have been delivered to the canons from the pulpit.

The refectory was subsequently divided into two by the insertion of a cross wall, and a large fireplace built in the eastern half to create a **warming room** (**16**), at some monasteries the only room in which a fire was allowed to be maintained throughout the winter months.

HISTORY

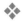

Lilleshall Abbey was founded around 1148 when Richard de Belmeis settled a group of Arrouasian (later simply called Augustinian) canons at the site, probably at that time in temporary wooden buildings. The size of the monastic complex and the evident style and quality of its buildings attest to the existence of rich and powerful benefactors, though little detail is known of how the abbey's various endowments came about. As well as gifts and legacies, the abbey derived an income from its farmland, from ownership of two water mills, from investments in property including buildings in nearby Shrewsbury, and from toll charges for the use of Atcham Bridge over the River Severn. The abbey's local land holdings were quite extensive, and consisted of four granges from which the estates were managed and farmed.

Even so, by the early fourteenth century the abbey heavily in debt. The abbot was accused of not consulting the community sufficiently about business matters and selling wood from the forests on his own authority. The abbey's finances were also undermined by the reckless selling of corrodies. Corrodies were a sort of 'pension policy' that could be bought by lay people: in return for a gift of cash or land the abbey would provide cash, lodging, fuel or food for that person until their death. If the person died quickly, the abbey would benefit from the gift, but if they lived for a long time, the outlay could become a burden.

Seal of Abbot Alan (c.1220–26)

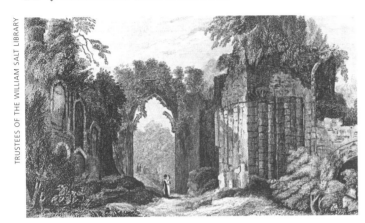

Engraving of the interior of the abbey church by Francis Calvert, 1830, showing how overgrown the site had become by the mid-nineteenth century

Engraving by Samuel and Nathaniel Buck, 1731

DISSOLUTION

An inventory from the time of the abbey's suppression in 1538 recorded that the property and goods of the abbey were sold for a sum of around £75, and that along with the abbot there were nine canons and 43 servants at the abbey, including a schoolmaster.

The last abbot received both a pension and a house, while the canons are recorded as being equally fairly treated, with the servants also receiving small sums in compensation.

The inventory indicates that most of the buildings of the abbey were to be stripped out and gutted, as is suggested by the sale of the tile pavements in both the church and the lady chapel, the glass windows and stone-floor flags in the chapter house and of the roof timbers, shingles and paving stones from the cloister. The site then passed to the Cavendish family, who sold the property just one year later to James Leveson of Wolverhampton.

LATER HISTORY

During the Civil War, the abbey was fortified by Sir Richard Leveson on behalf of King Charles I, and in 1645 held out briefly against a siege by Parliamentary forces that appears to have damaged parts of the church and buildings in the cloister, perhaps through cannon fire. A ditch to the north of the abbey may have formed part of the Parliamentary siegeworks, while excavations inside the refectory in the 1980s uncovered a hearth that may have been used by the Royalist defenders to cast lead gun shot.

Following the Civil War the abbey appears to have been in a partially ruinous state, and was left to decay. At some time during the seventeenth or eighteenth century the refectory was converted into a cottage which continued in use until the nineteenth century, when it was demolished and the interior area laid out as a herb garden.

The abbey was placed in the guardianship of the Office of Works in 1950, and was subsequently repaired and consolidated, and is now in the care of English Heritage.

MORETON CORBET CASTLE

TOUR AND DESCRIPTION

Walk inside the central, open courtyard of the castle, a short distance from the site entrance.

What you see around you are the defensive elements of the castle – the curtain wall and keep – dating to a number of phases of construction, although much of the original circuit of the curtain wall has been demolished or reduced in height. Openings in the curtain wall, wide on the inside and narrow on the outside, represent firing stations for the castle's defence.

The now-open inner courtyard may once have been partly filled with timber buildings, of which no traces remain. Inside the late twelfth- or early thirteenth-century keep there is a fireplace with decorated capitals at first-floor level.

Leaving the courtyard and walking around the outer circuit of the curtain wall in a clockwise direction, you arrive at the surviving remains of the Elizabethan wing. This is best

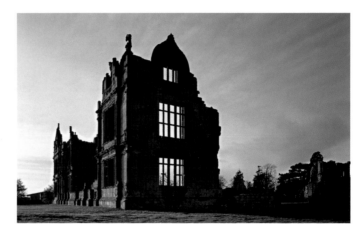

The Elizabethan wing

understood by examining the main facade while referring to the reconstruction drawing of this elevation on the display panel.

The inspiration for the house very clearly came from Italian buildings of the period, but the finished building would appear to have been very much in an English tradition, with some of the carving being particularly rustic in finish. Little survives inside, with the exception of a large decorated fireplace.

A short walk away is St Bartholemew's Church which contains some fine tombs of the Corbet family.

HISTORY

Shortly after the Norman Conquest of 1066 a small fortified house, protected by a timber rampart and a ditch, was constructed at Moreton Toret, as the site was then known. Around 1239 the Corbet family acquired the site by marriage and built a stone castle, very much in the tradition of other fortified residences along the then-lawless Welsh Marches.

Further building work took place in 1538, when Sir Andrew Corbet had the castle remodelled. His son Robert, English ambassador to Italy, 'with an affectionate delight of architecture began to build ... a most gorgeous and stately house after the Italian model', according to the antiquarian William Camden. Influences evidently included the architect Palladio's Convent of Santa Maria della Carità in Venice and his basilica at Vicenza. Robert died of plague in 1583 and the house was never finished, though the Elizabethan wing that survives in part today testifies to his ambition.

During the Civil War Sir Vincent Corbet fortified the house in support of King Charles I and strongly garrisoned it with a force of 110 men, yet it was captured by a Parliamentarian force of only ten troopers who tricked the Royalists into surrender after a minor skirmish in the dead of night. When the Parliamentary forces left the castle was burned down, and it has remained an uninhabited ruin ever since.

Acknowledgements and Further Reading

Previous guides to Haughmond Abbey, by R. Gilyard-Beer and Gill Chitty, the Lilleshall Abbey guide written by Stuart Rigold, and the Shropshire volumes of the Victoria County History have provided much information that has saved me from 'reinventing the wheel' in preparing the text for the new guide. Likewise Steve Litherland, my colleague at Birmingham University Field Archaeology Unit, has allowed me access to his research notes on Moreton Corbet Castle and to reuse some of that text. Finally, I would like to thank Therese Nation for her background research work on the historical and illustrative sources.

The single most valuable source for Haughmond Abbey is its cartulary. The most accessible text of this, with commentary, is: *The Cartulary of Haughmond Abbey*, edited by Una Rees. Shropshire Archaeological Society and University of Wales Press, 1985.